Landscapes in Acrylics

DAVID HYDE

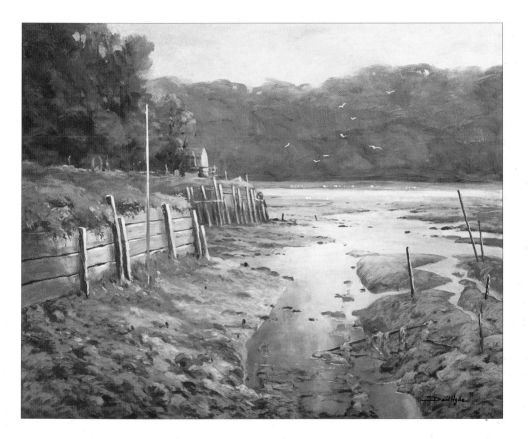

D0294370

1805134226

This edition first published 2014

Search Press Limited
Wellwood, North Farm Road,
Tunbridge Wells, Kent TN2 3DR

Originally published in Great Britain 2006

Photographs by Steve Crispe and Charlotte de la Bédoyère

Product photograph at the bottom of page 6 supplied by
Winsor & Newton

ISBN 978 1 84448 978 7

The Publishers would like to thank Winsor & Newton for
supplying some of the materials used in this book.

Suppliers
If you have difficulty in obtaining any of the materials or
equipment mentioned in this book, then please visit the Search
Press website for details of suppliers: www.searchpress.com

Publisher's note
All the step-by-step photographs in this book feature
the author, David Hyde, demonstrating how to paint
landscapes with acrylics. No models have been used.

Printed in Malaysia

*I would like to thank Vernon Cope, my art teacher, for all
his early encouragement; David Chambers, who made me
think hard about my work when I started to get serious
about my painting; my agent, Dennis Horwood of
Art Profile, for making it possible to paint full-time, and
everyone who has supported me and played a part in my
painting life, especially Roz Dace of Search Press who first
saw my work and invited me to produce this book.*

*To my wife, Maureen; her love, support and faith
keep me going.*

Cover
Woodland Edge – Bluebells
45 x 35cm (17¾ x 13¾in)
The Spring sun shone on these blue flowers and their fresh
green foliage, contrasting starkly with the grey tones of the
wintry looking trees. I added yellow to the foliage to strengthen
the effect of strong sunlight. This complemented the slightly
purple-blue of the flowers, creating a pleasing pattern on the
woodland floor. The trees in the actual scene needed to be
thinned out and simplified and were added only where they
were needed in order to strengthen the overall composition.

Page 1
Low Tide at Wootton Creek, Isle of Wight
51 x 41cm (20 x 16in)
The creek provides the lead-in to this painting. Because of the
wooded hills at the back, the sky occupies only a small area.
Even so, it is good to reflect some of the unseen sky colour in
the water. Overall the tones have been kept in the medium to
light range and the soft light from the right of the picture helps
convey a mood of morning stillness. The wood pilings making
up the jetty were very dark. I had to lighten them to make
them work in the painting.

Opposite
Dartmoor Farm
41 x 30.5cm (16 x 12in)
The colours in this painting were kept muted and reflected the
purple and ochre hues of the surrounding moorland landscape.
Extensive use of transparent glazes throughout this painting
gives it the soft feeling of a watercolour. The area around the
gorse bushes was loosely masked and spattered with yellow to
represent the gorse flowers.

Contents

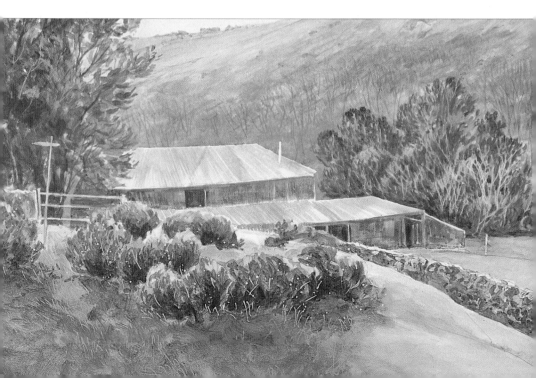

Introduction

"I can't get on with acrylics; they dry too quickly." "I find acrylics too bright and the effects not very subtle." "I much prefer a more traditional style of painting." These are all sentiments I once shared. These 'problems' still cause people concern, and I hope that if you share these views, your heart and mind can be won over.

Acrylic is arguably the most versatile medium. You can paint on most surfaces including paper, wood and fabric. You can paint in most styles from watercolour-like glazes to thick impasto. You can use it for creating collages, where the paint itself provides not only colour and texture but adhesionas well.

There is a large and daunting choice of acrylic products available, but the hints and tips in thisbook will help get you started. It is tempting to buy a large variety of colours and equipment, but keep things simple initially. You will learn more about the medium by experimenting with mixes that are possible from just a few colours.

During the many years I have been painting with acrylics, I have developed techniques that overcome all the 'problems' listed above. It is an approach based on a watercolourist's need to work quickly and directly. I do hope you find the contents of this book useful and inspiring.

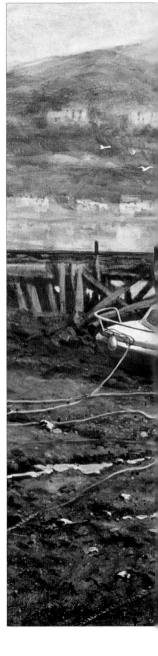

Teignmouth Harbour
51 x 41cm (20 x 16in)

The subject (the boat) dominates the composition in this painting. Pools of water in the low tide mud provide not only a lead-in through to the background, but also an area at the bottom of the painting where the light, reflected sky tones can be introduced. The position of the mooring ropes was altered to strengthen the lead-in effect. Splatter and glazing techniques were used to give the foreground interest, form and texture.

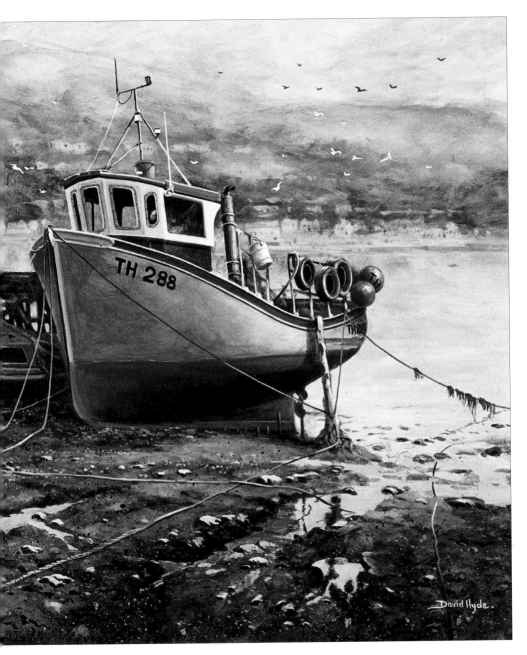

TH 288

David Hyde.

Materials

There is a wide selection of products available, but remember that quality is always better than quantity. Always buy from a recognised manufacturer. There is no point adding the problems that inferior materials bring!

Paints

Most manufacturers produce an artist's quality and a student's quality range. The artist's range offers a greater choice and the colours are more intense, but this comes at a price. The majority of leisure painters find the student's range perfectly acceptable. It is more important to be generous with your colour mixes and not worry about 'wasting' expensive paints.

You do not need many colours to get started. It is best to begin painting with just a few colours and get to grips with their mixing properties. You can actually produce an excellent painting with only one colour, as tone is much more important. I use quite a restricted palette. Over the years, I have tried a large number of colours, most of which I use only occasionally.

Mediums

In order to understand why and when a medium is to be used, we need to know a little about the 'make-up' of acrylic paint. All paint consists of a dry, coloured pigment held together with a liquid binder. In oil paint, this binder is a slow-drying linseed oil; in watercolour it is a soluble gum arabic; whereas in acrylic, it is a fast-drying synthetic resin. There is another component to the mix which is simply water. As acrylic paint dries, the water evaporates and the polymers in the resin bind together to make a permanent, flexible film. Water helps the paint flow and you can increase the flow by adding more water. However, if you add a lot of water, not only will the colour lose its brilliance, but over-dilution will prevent the polymers binding effectively and may cause an unstable layer in your work. The solution to producing transparent

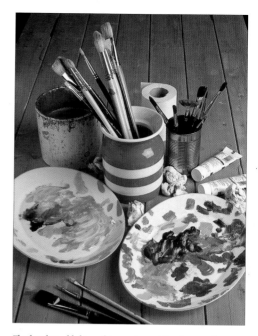

Flat brushes, old china plates, water pot, brush pot, toilet tissue, cleaned-up tin for holding small brushes, and tubes of acrylic paint.

washes, or glazes, of acrylic colour is to dilute the paint with a medium – a synthetic resin with no pigment. Although it dries transparently, it is milky when you mix it with your paint. Normal amounts of water can be used to adjust the flow of the mix.

Mediums are available in a gloss or matt finish, as a gel or a more fluid consistency.

A retarder is a medium designed to slow down the drying time of acrylic paints. However, my method of painting with acrylics differs from many in that I do not feel the need to slow down the drying time in this way. Acrylic's quick drying property is only a problem if you try to use them like oil paints. An oil painter works with wet colours and has plenty of time to blend and create softness. I work by applying simple, quick applications of paint: mid-tones, then light tones, then dark tones, and let each one dry before applying the next.

Palettes

Old china dinner plates make the best, and cheapest general purpose palettes when painting indoors. Make sure they have a shiny glazed surface so that they are easy to clean. Even dried paint will clean off easily after a short soak in warm water. Pick plates with little or no pattern and it is best if they are white or a neutral colour.

Acrylic stay-wet palettes can be used indoors and out (as long as the sun is not too hot). The stay-wet palette consists of a shallow tray with a tightfitting lid. It contains an absorbent layer (blotting paper or sponge) for you to soak in water. This is covered by a non-absorbent paper. Your colours are set out and mixed on this. As long as the lid is on, the colours within will remain usable for many days.

Traditional wooden palettes are useful when working outdoors on hot sunny days. Acrylic sticks permanently to wood so simply squeeze fresh paint on top as the sun dries it out. You can work quickly and, best of all, you never need clean your palette!

Tear-off palettes are useful when working outdoors on cooler days. They do not need cleaning so you do not need to carry extra water.

My unwashed wooden palette.

Brushes

Good quality brushes are important for all forms of painting but luckily brushes for acrylics do not cost a fortune. Brushes will wear out and most will need replacing, particularly those needed for detail. Some worn brushes can become useful for adding texture effects. A small selection of sizes will get you started. I find brushes between 10mm ($^3/_8$in) and 25mm (1in) are most useful and that usually translates as numbers 4, 6, 8, 10 and 12, but sizes can differ between manufacturers. In all cases however, the higher the number, the bigger the brush. A no.12 flat, for example, is roughly 25mm (1in) wide.

A selection of my favourite brushes.

Hog bristle short flats – numbers 4 to 10 (up to no.12 if you paint larger than 30 x 40cm (12 x 16in). Keep your old, worn ones for adding texture.

Acrylic synthetic flats – in similar sizes for smoother, less textured paint application.

Acrylic synthetic rounds – numbers 1, 3 and 5 for detail.

Acrylic synthetic riggers – numbers 0 or 1 for fine wwwlines, branches, twigs, etc.

Bristle or texturing fan brush – medium size for suggesting foreground foliage detail.

Supports

The surface on which you paint is traditionally called a support. Canvases and canvas panels are the most popular supports commercially available. They have a slightly textured surface and come in a variety of standard sizes. However, I prefer a smooth surface so I prepare my own boards for painting. This is easy and inexpensive, with the added advantage that you can produce any shape or size you want. I use MDF (medium density fibreboard), a smooth builder's board available from DIY stores. It comes in several thicknesses but 2mm ($^1/_{16}$in) and 6mm ($^1/_8$in) are best for painting. I use 2mm ($^1/_{16}$in) as most of my paintings are mounted and framed under glass. When buying MDF, check the board for warping and surface imperfections.

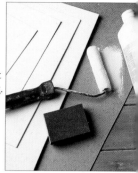

MDF boards with a roller, acrylic gesso and sandpaper block for priming.

Your board will need priming before you can paint on it. Gesso is a white, opaque acrylic primer available in bottles or tubs from art shops. Make sure your board is flat, apply some gesso to the surface and, using a dampened 11.5cm (4½in) 'sheepskin' roller, spread the gesso evenly over the whole board to seal the surface. Let it dry (you can speed this up by using a hairdryer), then use a medium sandpaper block from your DIY store to achieve a smooth surface with a fine, sugary texture. Repeat this process to produce a smooth, white surface. A coat of gesso or a cheaper primer on the back will prevent warping.

Easels and outdoor equipment

You may not feel the need to use an easel. Many artists prefer to work flat or at a slight angle, in which case all you need is a table of some type to work on. However, there are many types of easel available. Sketching

easels are portable and ideal for outdoor work or taking to your art club. Metal types are more rugged than the wooden ones and are a better choice. I use a square-section aluminium easel with legs that extend like a camera tripod. Studio easels are more substantial wooden easels. Their weight means that they are suited only to indoor work. Do check the height of your ceiling if you intend to buy one, as most are designed to extend to quite a height. Table easels stand on your painting table and are ideal for home or art club painting if you prefer to work at an angle. Box easels are a useful asset; they are wooden easels combined with a box to carry your materials. Designed to be used outdoors, they adjust easily so you can paint in a sitting position or with your work flat. However, they are quite heavy, especially when full of materials, which can be tiring if you need to carry one about for long periods.

When working outdoors it is important to be comfortable. A trip to your local fishing-tackle shop will provide a choice of sturdy, adjustable fold-up seats with backs designed to keep the most robust carp angler comfortable for hours. I can set mine low so that I can work with all my equipment around me on the ground. You will also find a selection of strong boxes capable of holding all your equipment, including your lunch, and these can double as a seat if you can work without a back support. Fix a carrier bag using some masking tape between the legs of your outdoor easel and you will have an instant rubbish bin for dirty tissues – believe me, you will use more than you think!

Other materials

An A5 sketchbook is very useful for working out your composition. Do not worry if the idea of sketching is alarming; your sketches can be quite crude and can include written notes about tone, colour or anything you want. A sketchbook is like a diary – you need not show it to anyone!

I prefer charcoal to pencils for drawing on a canvas or other gesso-primed surfaces. Pencil marks are difficult to erase, whereas charcoal marks can be removed with a damp sponge.

Masking tape is useful when you need to make a completely straight line for, say, a horizon. It is also ideal for masking or protecting areas of the painting as you work. Low-tack masking tape is best.

You can create texture with natural sponges and splatter effects with an old toothbrush. I have also invented my own tool for adding texture, the bungee brush (see page 18).

A rubber-tipped colour shaper can be used for lifting out colour.

A water mist spray and roll of cling film are useful for keeping your colours moist and usable. Just spray your palette and cover it with cling film – it will act in a similar way to a stay-wet palette.

A washing-up sponge is indispensable for general palette cleaning and correcting charcoal marks. Dry your brushes and palette with paper towels or toilet tissue.

There will be times when you will need to speed up the drying process and a hairdryer will do the job.

A digital camera is a wonderful luxury because you can see your pictures instantly. If you have a PC or laptop near to where you paint, you can refer to your images directly without having to make prints.

Clockwise from bottom: A5 sketchbook, cling film, old toothbrush, acrylic medium (see page 6), water mist spray, rubber-tipped colour shaper, pencil, charcoal, bungee brushes, natural sponge, washing-up sponge, masking tape and an eraser.

Composition

Composition is more important than drawing. I use charcoal because it stops you getting too distracted with detail. You can rough in your composition very quickly but do stand back and look at it long and hard before proceeding. If something is wrong, you can quickly correct it. If you have spent a couple of hours on your drawing, you are less inclined to make any alterations. Do not worry about detail; you can put this in with paint later.

Consider for a moment a still-life painting; a real classic with fruit in a bowl, a wine bottle and half-filled wine glass and perhaps a few walnuts and vine leaves in the foreground. Now ask yourself – did the artist come upon this scene by accident and decide to paint it? No, of course not. Something, perhaps the fruit in the bowl, would have been the initial inspiration and the other items were added to create a picture. This selection of objects and their placement relative to one another is called composition, and composition is important in all paintings.

You may be thinking that surely landscape is different. You can move a wine bottle but you cannot move a church; you can arrange a vine leaf but a river is fixed in position. Well, not only is it possible to rearrange a landscape, but artists have been doing it for years. Mentally select objects from the scene in front of you and place them in your painting to create a composition. You need not select everything and you are quite at liberty to alter or even add objects to create the effect you want. This is known as artistic licence and your paintings will look all the better for it.

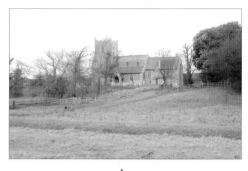

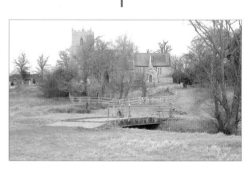

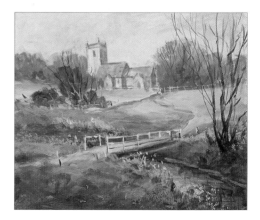

Holywell Church – a compositional study

In the middle photograph the church is obscured by trees. For a clearer view, the photograph above needed to be taken from across the bridge and to the right. In the resulting study, I reduced the size of the obscuring trees and added the church detail using the second photograph. Additionally, the existing footpath was emphasised to link the bridge and the church, strengthening the composition.

Golden section

When you look at any picture, your eyes will scan most often the areas one-third in from the edges. So, as an artist, you can 'guide' your viewer's eye to rest more easily on the focal point by placing it one-third of the way in from any edge. This placement is known as the 'rule of thirds'. There are four points where the vertical and horizontal thirds cross, which is called the golden section. By placing your focal point in the golden section (see example), its strength in the painting is bolstered.

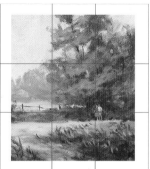

The two figures in this study are small but become a strong focal point when placed on a golden section.

Focal point

The focal point of a picture can be the subject, part of the subject, a bright colour or a dramatic contrast in tone. Whatever it happens to be, the eye must naturally return to it and be able to rest. Have only one focal point or the picture will seem confused. If human figures are included, even if they are quite small, our brains accord them more importance than their size warrants and they can, even unintentionally, become the focal point of the painting. This is also true, though less so, of animals. They must strengthen the focal point and not distract from it.

Eye level

I live on the edge of the Fens in Cambridgeshire where the horizon is mostly visible and not obscured by hills or mountains, but usually the horizon line will be hidden. You still need to know where it is and where to place it in your painting. This can seem a difficult task but you just need to think of an imaginary line at your eye level. To determine the eye level from where you are standing or sitting, look straight ahead and move your head from side to side. Represent this imaginary line with an actual mark on your painting board. Where you place this mark is up to you, but keep the golden section in mind for your focal point. One-third from the top or bottom of the board can be a good start. A low horizon line adds drama to tall objects such as trees and high buildings. If you choose a horizon line in the middle, beware of cutting the painting in two and making the picture look static, unless you are deliberately trying to create a feeling of peace and tranquillity. A high horizon line will focus interest on the foreground to mid-distance. Do not be afraid to let tall objects disappear out of the top of your picture.

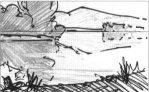

The three sketches show from top to bottom: low, middle and high eye level.

11

L-shaped composition

An L-shaped composition has a strong upright element, often a tree, placed on or near a vertical third and a strong level element placed on or near a horizontal third. The focal point, meanwhile, can be placed near the opposite vertical third. The upright is dominant but never the focal point. The bottom section of the 'L' should lift the viewer's eye up into the picture. This can be achieved with some close-up vegetation or even a strong shadow across the picture, below the bottom third.

River Scene
The jetty and the tree make up the L-shape in this composition.

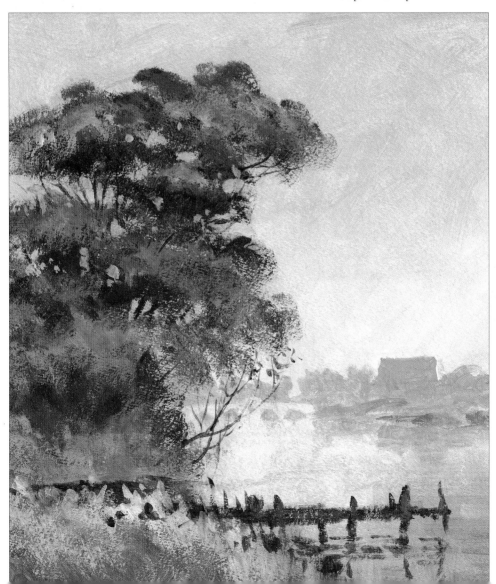

U-shaped composition

Similar to the 'L' but with a second, normally less strong, vertical used on the opposite third. This gives a more enclosed feeling to the painting and is often used in woodland or street scenes. The two verticals act as a frame to the focal point, which can now be placed nearer to the centre of the picture. Again, the bottom section of the 'U' should lift the viewer's eye up into the picture.

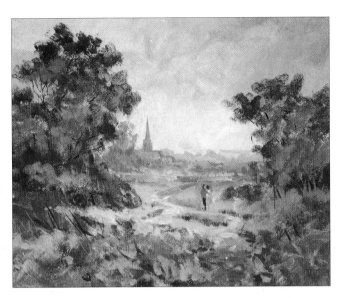

Woodland Edge
The foreground shadow completes the U-shape in this composition study.

S-shaped composition

An S-shaped composition will give a more open feeling to a picture and can be used when painting scenes that lack vertical trees or buildings, such as mountain or beach scenes. The 'S' shape can take an obvious form, like a road or stream leading your eye in and around the painting. Or it can be subtler, using field edges, different areas of landscape colour or cloud shadows to form a pattern that leads the eye. The focal point can now be placed on a third or any of the golden points.

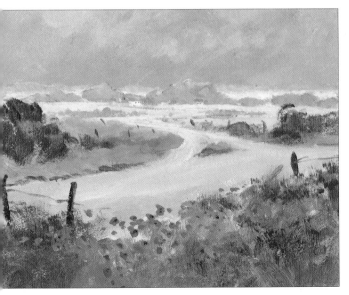

Landscape with Poppies
The S-shaped road leads the eye through this picture.

Colours

You can paint a picture with just three primary colours, because from these you can mix a version of all others. The only addition is white to control the tones. Most artists use a palette based on three or more of each of the primaries to give themselves a greater range when mixing. A useful, basic palette is listed below.

Yellows

Lemon yellow A bright, sunshine yellow. It adds warmth to whites and freshness to greens.

Naples yellow A non-insistent yellow that can lighten tones and add softness to many mixes.

Raw sienna A 'must-have' colour. The dull yellow is useful for grass greens, brickwork and so on.

Reds

Cadmium red A useful bright red. Warms up mixes wonderfully.

Cadmium orange A versatile colour – good for sunsets, sunny brickwork, toning greens and much else.

Burnt sienna Another vital colour, a dull red or warm orange brown with many uses.

Burnt umber Use sparingly. Mix with phthalocyanine blue to make a lovely deep green.

Blues

French ultramarine A most versatile, warm blue, useful for making greys and distant greens.

Phthalocyanine blue (phthalo blue) A strong, cool blue which is good for skies but most useful in making greens.

Cerulean blue A good soft, sky blue. Useful for distant shadows and for mixing soft greens.

Useful secondaries

Chromium oxide green A useful base for many green mixes and a good unifying colour to use all over a picture.

Dioxazine purple Great for underpainting shadow areas. Good in shadows and grey mixes.

Whites

Titanium white You will need plenty of this white for mixing with and toning in all colours.

Mixing greens

In my basic list of paints I have included a useful, general purpose green. However, if you are a beginner, I would suggest locking away any green you may have for the time being; the temptation to reach for it in times of crisis will be too strong. We all know that blue and yellow make green, but there is much, much more to it than that!

Add white to the mixes below to vary the tone. However, adding white can make greens look too cool and minty. If so, substitute Naples yellow to warm up your greens.

Grass greens

Spring grass
Lemon yellow + phthalo blue

Summer grass
French ultramarine + lemon yellow

Autumn/winter grass
Cerulean blue + raw sienna

Tree greens

Summer trees
Phthalo blue + a little burnt sienna

Autumn trees
Burnt sienna + a little phthalo blue

Spring/winter trees
French ultramarine + burnt sienna. For spring trees overpaint with small amounts of yellow-green to suggest new growth – see page 20.

Colour and tone

Now we have discussed mixing, we ought to clarify the difference between colour and tone. Red, blue, green, purple and so on are colours: degrees of lightness and darkness of that colour are called tone. This sounds simple enough and in the monochrome example shown, painted only in burnt sienna (plus white to control tone), it is easy to see that all the elements of light, shade, foreground and distance are perfectly readable.

In most paintings where you use many colours, you have to judge the tone of each colour against the tone of the different colours and tones in the picture. If you have a digital camera, you can quickly assess the tones in your painting as a whole. Take its picture and remove the colour, making it either sepia or black and white. Your painting should still look 'correct'. The elements should still appear in their proper place. After all, many of us watched black and white television quite happily for years. Being able to alter the tone of a colour is more important than mixing different hues.

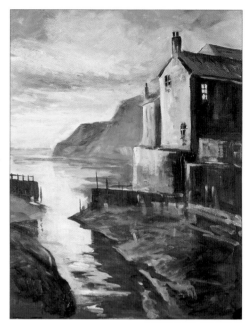

Evening Low Tide
A monochrome study painted in only burnt sienna and white.

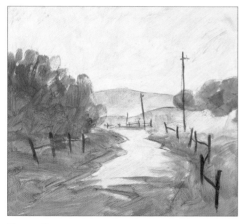

Country Lane
A tonal underpainting painted in raw sienna, burnt sienna and dioxazine purple.

Tonal underpainting

An underpainting is a very useful thing and has three functions. On a practical level, the underpainting will seal the drawing, which is particularly important with charcoal. It will also cover the whiteness of the board, which is handy when painting in the sunshine, and it makes it a lot easier to judge tonal values as you paint.

I use three colours: raw sienna to establish the light areas, raw sienna mixed with burnt sienna for general distance and mid-distance tones, and burnt sienna for foreground tones. Dioxazine purple can be added to all mixes to indicate areas of darker shadow. Mix your colours with medium to make them transparent and you will not lose your drawing detail. There is no need to use white as the whiteness of the board will show through the transparent paint. Leave to dry thoroughly.

Creating depth

In landscape painting, we are trying to represent the three-dimensional scene in front of us on a two-dimensional board. The scene will have some objects close to us, some a little further away and so on until we come to the most distant objects we can see. The illusion of distance needs to be created in our paintings. If done successfully, it will give our pictures depth.

Linear perspective

The further away from us an object is, the smaller it will appear. A straight line of telegraph poles going away from us would appear to get smaller and smaller. This effect is known as linear perspective, commonly referred to just as perspective. If the line of telegraph poles were long enough, they would eventually seem to disappear at a point on the horizon called the 'vanishing point'. In landscape these effects are drawn with a pencil or charcoal line. Look at the line drawing on the right to see how linear perspective creates the illusion of depth.

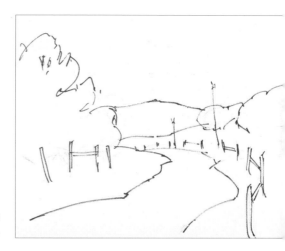

Country Lane
A study in linear perspective.

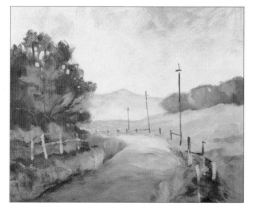

Country Lane
An study in aerial perspective.

Aerial perspective

Tone will also be affected by distance. The further away an object is, the lighter, less detailed and less contrasting its tone will appear. This can be achieved simply by adding white to your mixes, and reducing the amount of detail. You can paint dark colours in the distance, but they must be lighter than the equivalent foreground darks. This recession of tone, contrast and detail is caused by water droplets and pollutants in the atmosphere, and is known to artists as aerial perspective. If you can successfully combine linear and aerial perspective, you will create a true feeling of depth.

Useful techniques

There are many different brushes and many ways to use them. There are also different ways to apply and mix paint. Having a few tricks of the trade up your sleeve will help to solve problems you encounter when painting.

Scumbling

A brush that will give you a good textured mark is useful here. A hog bristle, new or worn, is the one to use. Load your brush with a stiff mix of paint and apply with downward pressure on the bristles, twisting them vigorously as the paint is applied. You can scumble several colours together. Let the random movement of the stiff bristles create lines and textures on your painting surface.

Dry brushing

Another useful technique, similar to scumbling but producing a much softer effect. Any brush can be used. Dip your brush in the paint and then wipe off most of it with a cloth or tissue. Lightly 'dust' on the paint with a circular motion. Let it dry before you build up further layers. With this effect you can paint smoke, mist or cloud effects.

Rigger brush

Rigger brushes were developed for marine artists to overcome the difficulty of producing long, fine lines to paint a ship's rigging. There are many uses for fine lines in landscape painting. I use the rigger when I paint winter trees. The paint mix must be quite liquid and must flow from the brush freely. If it drags, add more water.

Bungee brush

The bungee brush is my own invention and can be made by modifying a bungee luggage strap. Simply cut off a length about three inches long. Cut away some of the fabric sheath and smear it with epoxy adhesive to prevent fraying. Pull apart the individual strands of rubber and trim to the length required. Some straps have very thin rubber strands; the thicker ones are the most useful. The brush will produce all manner of random, natural looking textures.

Natural sponges

It is often useful to produce a convincing, random effect with paint that may seem difficult or time-consuming with brushes. Perhaps the most used effect created with natural sponges is the foliated, many leafed, effect. Natural sponges have a more random texture than synthetic ones. Dip the sponge lightly into a fairly stiff mix, taking care not to pick up too much paint. Lightly dab the colour into the area required. Sponging can cause repeated shapes: twist the sponge around to avoid a 'potato print' look.

Splattering

Colour can be splattered on to your painting. Different effects can be achieved by flicking wet paint off either your paintbrush or an old toothbrush. A variety of suggestive, spotted, speckled effects can be useful when painting foliage, rough ground, brickwork, earth and sand.

Misting

Small atomising sprays can be bought from chemists or art shops and filled with water. Apart from their use in spraying your palette to stop paint from drying out, they can also be used in painting. Sponging and splattering effects can be altered and softened by spraying the area with water prior to texturing, or by spraying over the wet textured area after application. Both ways will soften the effect of the textured mark.

Masking

Masking involves protecting an area of your board whilst applying paint. While splattering, for instance, pieces of scrap paper can simply be laid over areas to protect them from paint spots. This is known as 'loose masking'. Low tack, or decorator's masking tape can be used to create a level line of paint, a seascape horizon for example. Make sure all the paint is dry before applying the tape. Do not press it down too fiercely. Once in place, paint the area up to and over one edge. Remove the tape before the paint dries to leave a perfectly straight line .

Glazing

Glazing is the technique of applying a layer of transparent colour over another, dry, layer of paint. It was used by the old masters with oil paint. To glaze with acrylic takes a fraction of the time. Medium is added to the paint. The more medium, the greater the transparency. Whole areas can be modified, warmed or cooled by applying glazes. Shadows can be 'glazed' in to enhance the effects of sunlight. In the picture I am applying a raw sienna glaze over an area of texture.

Colour shaper

Texture marks can be made into wet paint with a hard rubber-tipped colour shaper. Paint can be 'lifted' out, revealing the colour underneath.

Seasons

Spring
30.5 x 25cm (12 x 9¾in)

*The use of cerulean blue and Naples
yellow gives the sky tones a spring
freshness. This is echoed by the use of
lemon yellow with a touch of phthalo
blue in the grass on the foreground
riverbank. The trees and bushes will
lack a full covering of leaves and can be
painted in warmer winter tree tones.
Small amounts of light yellow-green
randomly brushed over will suggest the
new spring growth.*

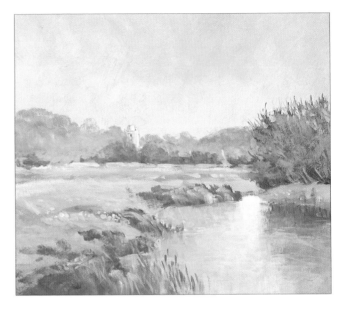

Summer
30.5 x 25cm (12 x 9¾in)

*An overall increase in contrast will help
suggest those rich summer landscapes. A
deeper, warm sky has been mixed using
French ultramarine and a little cadmium
red. Summer clouds have been used to
keep the sky from becoming too
oppressive and to give a light background
to the distant trees. Be careful not to
overdo the greens. Distant trees can be
painted using French ultramarine, raw
sienna and white, while the closer trees
on the right can be mixed using phthalo
blue, burnt sienna and Naples yellow. A
richer green of French ultramarine and
lemon yellow with white can be used in
the foreground grasses. The use of the
burnt sienna tone in the left foreground
breaks up the green and adds a warm
richness to the painting.*

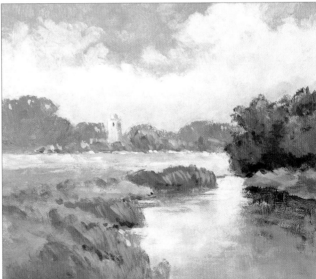

20

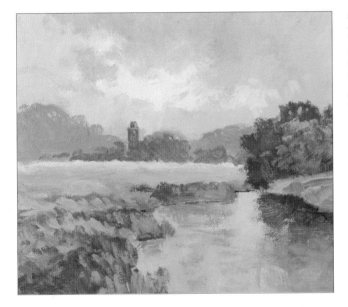

Autumn
30.5 x 25cm (12 x 9¾in)

The reds and golds have been kept under control here to avoid garishness. In this study I have warmed the painting overall by using cadmium orange in the sky mix. Cerulean blue mixed with cadmium orange together with plenty of titanium white makes lovely warm, grey clouds. There are still greens in the landscape but they now lack the richness of Summer. Mix them with cerulean blue and raw sienna or lemon yellow and lighten the mix with titanium white. The autumn trees are mixed from burnt sienna with a small amount of phthalo blue. Add white to control tone and add more white to paint the distant trees. Raw sienna and titanium white are used to suggest the waterside reeds dying back.

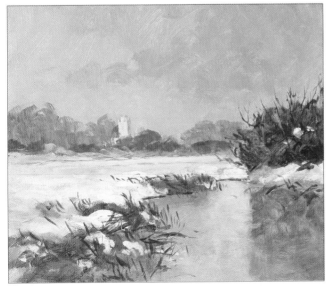

Winter
30.5 x 25cm (12 x 9¾in)

No landscape book would be complete without a snow scene. The sky and river tones are darker than much of the landscape in this study. I have used a similar mix to the summer sky but strengthened the tone a little. All the foliage is now painted with various greys, browns and ochres using mixes of French ultramarine, cerulean blue, raw sienna, burnt sienna and either titanium white or Naples yellow to lighten, replacing the green tones of the seasons before. Do not just paint the snow white. Add blues into the distance and areas of shadow. Naples yellow and small amounts of cadmium red or orange can be used in the sunny areas. The brightest snow in the foreground can be highlighted with white and a touch of lemon yellow.

21

Distant Mountains

On holiday on the Isle of Skye, Scotland, I took many landscape photographs like the one shown below. As with so many snapshots, the wide angle camera lens can diminish the effect of the mountains. The painting was created from this photograph using the road running to the left as a useful lead-in, increasing the mid-distance and making more of the mountains behind. This recreates the feeling of the scene that has been lost in the photograph. This composition is S-shaped.

You will need
Primed board, 46 x 36cm
 (18 x 14¼in)
Charcoal
Acrylic medium
Titanium white
Raw sienna
Naples yellow
Lemon yellow
Cadmium red
Burnt sienna
Phthalo blue
Cerulean blue
Chromium oxide green
Dioxazine purple
Rubber-tipped colour shaper
Brushes:
 No. 4, no. 6 and no.10 flat
 Rigger
 Fan

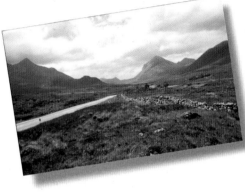

This photograph has all the basic elements for creating a Highland landscape. Note that the road needs some artistic license to make it work in a painting.

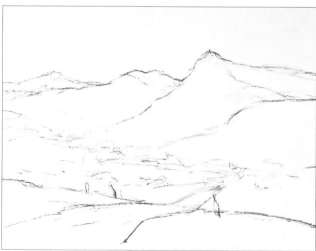

1. Use charcoal to sketch in the mountains on your primed board. Work quickly and concentrate on the composition. The beauty of charcoal is that it can be changed or rubbed away easily using a wet sponge, so try to be free and expressive with your marks.

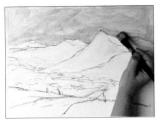 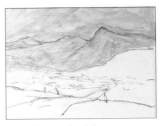 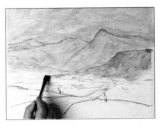

2. Mix medium with a little water and some raw sienna. Block in the sky using a no.10 flat brush. When you reach the top of the mountains, run your brush into the charcoal to seal it.

3. Add a touch of dioxazine purple to your paint mix and block in the mountains. Make brush strokes that follow the shape of the mountains, but keep them loose. The main objective is to cover up all of the white.

4. Add more purple to your paint mix and, using the no. 6 flat brush, block in the nearest mountain with brush strokes that follow the contours of your drawing. Using a fresh mix of medium and raw sienna, block in the mid-distance.

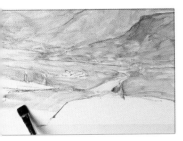

5. Use medium and raw sienna to block in the nearest section of path, as shown.

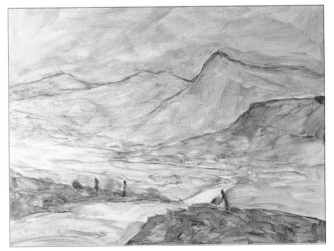

6. Add a pale purple shadow to the beginning of the road to lead the eye into the landscape. Paint the foreground grasses with burnt sienna. Make sure paint has been applied over all of the charcoal marks. This will seal the drawing. Allow to dry.

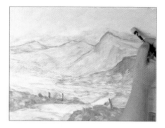

7. On your palette, add cerulean blue and a touch of Naples yellow to titanium white. Keep this pale blue mix fairly opaque; add very little water. Now block in the sky with the no.10 flat brush.

8. With the paint that is left on the bristles, dry brush over the mountains. Clean and dry the brush, then mix white and Naples yellow and paint a yellow haze above the mountains. Bring the yellow paint just over the top of the mountains to soften the edges and push them into the distance.

9. Make a mix of dioxazine purple, cerulean blue and Naples yellow to match the tone of the sky. Using the no. 6 flat brush, paint in the most distant mountain. Add more blue to the mix and paint the neighbouring mountain. Use a clean, damp brush to lift off small areas of paint where light hits the mountains.

10. With your blue mix, darken the top but not the front of the third mountain. Now add burnt sienna to the mix and strengthen the colour on the last mountain. Dry-brush the tops of both mountains to soften the colour.

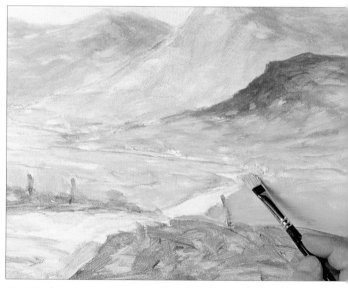

11. Mix chromium oxide green and Naples yellow with a small amount of titanium white to make a subtle green. Block in the middle distance and take the green slightly over the bottom of the mountains.

12. Using a mix of lemon yellow, burnt sienna and phthalo blue with a touch of dioxazine purple, roughly paint in the areas of foreground on either side of the path.

13. Before the foreground dries, use the rubber-tipped colour shaper to lift off small areas of paint. This will create the texture of foliage.

14. Use lemon yellow and cadmium red mixed with plenty of white to add highlights where the sunshine hits the third mountain with the no. 6 flat brush. Now dry brush the same mix where the sunlight catches the edge of the mountain range.

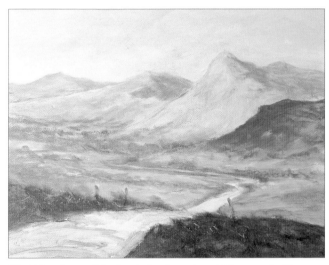

15. Using the no. 4 flat brush, break up the middle ground with shadows using a mid-tone green mixed from chromium oxide green, dioxazine purple and Naples yellow. Vary the proportions in the mix to create a range of shadows from bluish green to purplish green. Tone down the purple of the nearest mountain with a mid-tone green.

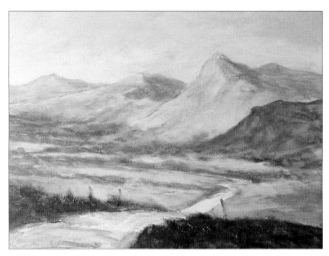

16. To make the middle ground look as though it is bathed in soft sunlight, add highlights with the no. 6 flat brush, using a mix of white and lemon yellow. Soften the nearest mountain with a purplish green.

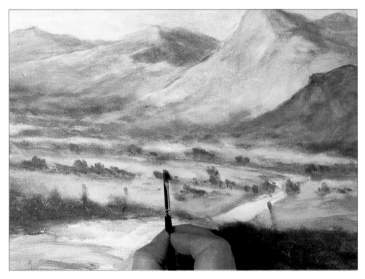

17. Paint in the trees with the no. 4 flat brush, using a mix of phthalo blue, burnt sienna and Naples yellow.

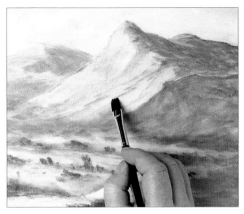 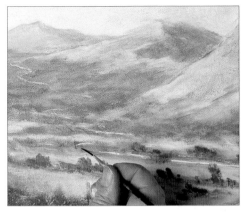

18. With the no. 6 flat brush, use a mix of cerulean blue, dioxazine purple and raw sienna to darken the tops of the mountains. Bring a suggestion of shadows down the front of the third mountain.

19. Add a touch of lemon yellow to white and use a rigger brush to paint the road meandering away into the distance. Paint a delicate, broken line to achieve this effect.

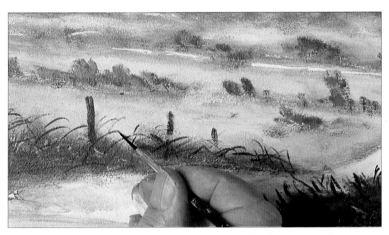

20. With the rigger brush and a mix of dioxazine purple, chromium oxide green and burnt sienna, add blades of long grass in upright strokes. Strengthen the fence posts using the same mix.

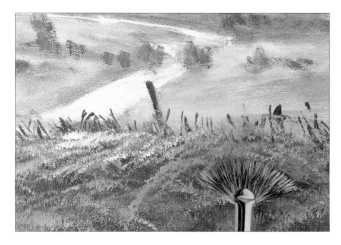

21. Use a fan brush to add highlights where sunlight catches the top of the heather. Create some highlights with pure white and others with various mixes of dioxazine purple, cadmium red and lemon yellow.

22. Add definition to the side of the road with a mix of burnt sienna and dioxazine purple, using the no.10 flat brush. Add medium and glaze in the shadow falling across the start of the road.

Do not be afraid to alter aspects of your painting even at quite a late stage. I felt the mountain needed more definition so I changed the shape slightly using a mix of dioxazine purple, chromium oxide green and cadmium red with a no. 6 flat brush.

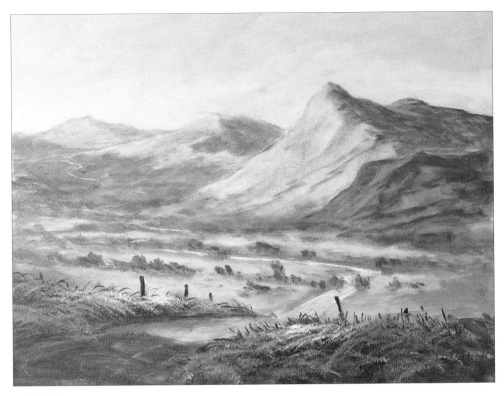

The finished painting.

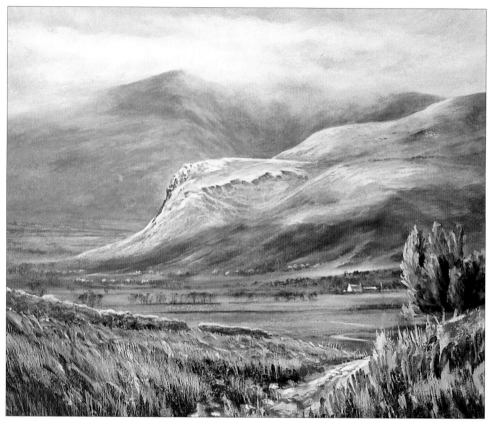

After the Storm, Cumbria
51 x 41mm (20 x 16¼in)

I saw this subject while driving in Cumbria. The sun was spotlighting the landscape through a gap in the storm clouds. The cloud and the patch of sunlight were moving quickly and by the time I stopped the car and grabbed my camera, the sun had moved too much to the left. I took the picture anyway and put the sunshine back in the 'correct' place when I did the painting.

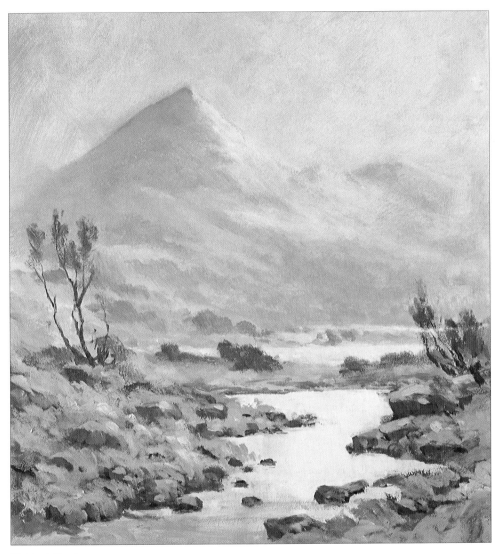

Highland Morning
33 x 36mm (13 x 14¼in)

Naples yellow has been used extensively in the colour mixes to suggest a low morning light cast across this landscape from the right. More has been made of the small brook to create a lead-in and provide a useful area to bring light into the lower part of the painting. I darkened the tops of mountains to emphasise their scale. Notice also how there is low contrast in the background, and higher contrast in the foreground. This is aerial perspective and its use will strengthen the effect of depth.

Still Water

This early morning scene photographed in my home town of St. Ives, Cambridgeshire, shows the River Great Ouse with almost no flow, providing some wonderful reflections of the church and distant riverbank. The church spire, the old mill building to the left and the foreground bushes make a useful composition group. The only small alterations I made were to widen the river slightly on the left and add to the floating weed to provide a stronger lead-in.

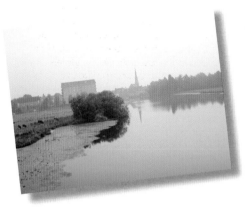

This view of St. Ives is from the bypass bridge. It is always worth a look upriver from this position. On this occasion the still water gave the town an air of peace and tranquillity.

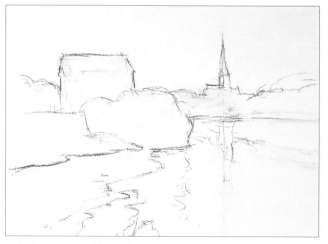

1. Make a sketch of the landscape on your primed board using charcoal.

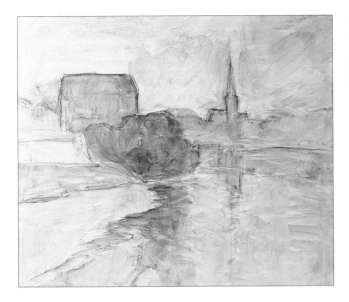

2. Use the no. 10 flat brush and raw sienna mixed with medium to underpaint the sky, the meadow, the duckweed and reflections in the water. Then mix raw sienna and dioxazine purple to block in the buildings and their reflections. Add a touch of raw sienna to burnt sienna and underpaint the bush and its reflection. When your undercoat is dry, paint a shadow in dioxazine purple at the base of the bush and bring the colour down into the reflection. Make sure the charcoal marks are covered and leave to dry.

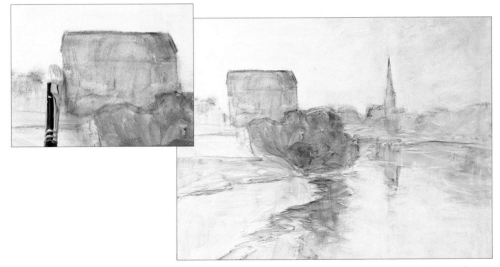

3. Use a mix of titanium white and Naples yellow to soften the sky and define the edges of the buildings. Then bring the same mix down through the reflections on the water.

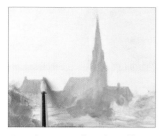

4. Make a mix of Naples yellow, dioxazine purple and a touch of cerulean blue. Add a little water to create a morning mist over the mill and the bushes to its left. Change to a no. 4 round brush when painting the spire.

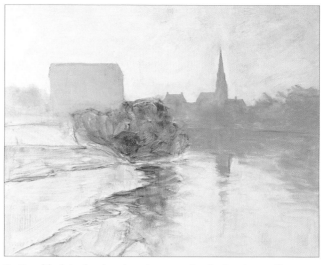

5. Now block in the church and surrounding bushes in a uniform tone. Then add the reflection, painting a broken reflection of the spire. Use the same mix and brushes as in step 4 but less diluted than before.

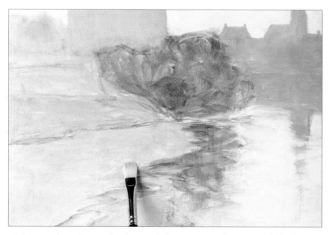

6. Mix Naples yellow with white and chromium oxide green and block in the banks on the left-hand side with the no. 6 flat brush. Naples yellow warms the green and, being a soft colour, is also good for distance.

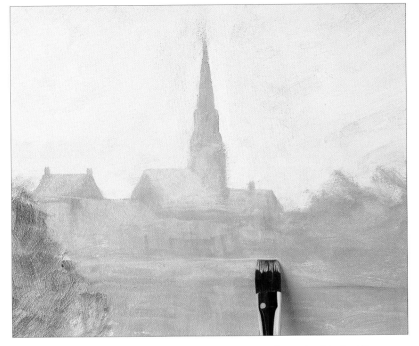

7. Mix some cerulean blue with titanium white to suggest the roofs of the buildings.

8. With a mix of Naples yellow and white, lighten the front of the mill building.

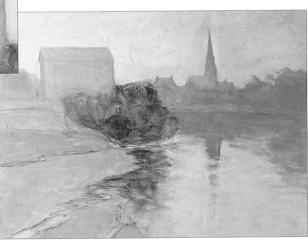

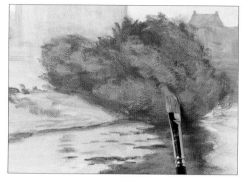

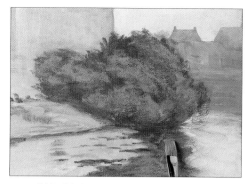

9. You now need to knock back the red. Mix burnt umber with chromium oxide green and paint the bush, allowing areas of the burnt sienna underpainting to show through. Work into the reflection forming the edge of the duckweed.

10. Add highlights to the bush using a mix of lemon yellow, white and chromium oxide green.

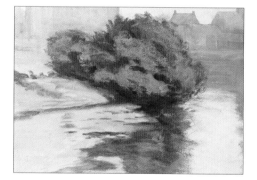

11. Strengthen the shadow beneath the bush using a mix of phthalo blue, burnt umber and raw sienna.

12. Using a mix of raw sienna, chromium oxide green and white, scumble across in front of the mill to create distant trees. Using a mix of raw sienna and chromium oxide green with less white than the previous mix, scumble in the bankside vegetation until it meets the bottom of the bush.

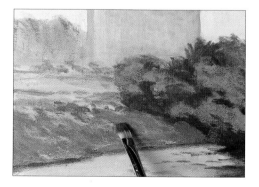

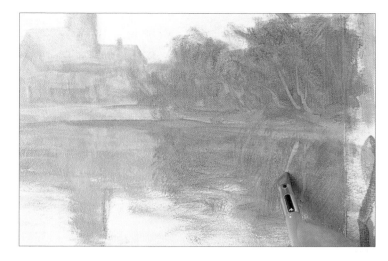

13. Add dioxazine purple to the first mix you used in step 12. Add water to make a wetter mix and give shape to the bush on the right by building up the shadows. Before the paint dries, use the rubber-tipped colour shaper to suggest reflections.

14. Using a mix of cerulean blue and white and a no. 4 round brush, add small dots to suggest holes in the top of the bushes.

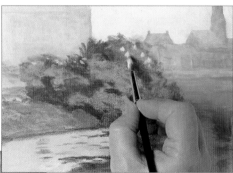

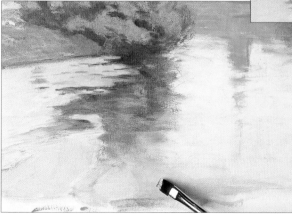

15. With the no. 6 flat brush, introduce some blue into the water using the same mix, slightly diluted.

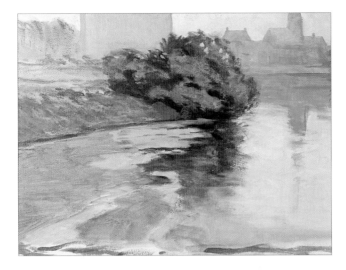

16. To create a shadow falling across the duckweed in the foreground, mix cerulean blue, phthalo blue and raw sienna and block in the area shown.

17. Using the rigger brush and a fairly watery mix of white and Naples yellow, paint some light branches on the bush. Then with a mix of burnt sienna, phthalo blue and raw sienna, paint darker branches and twigs poking out of the bush. Paint them all with quick, confident movements. When dry, tone down some of the paler branches with a shadowy glaze of cerulean blue.

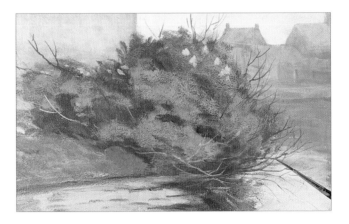

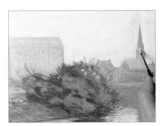

18. With the no. 4 round brush and a mix of white, cerulean blue and a touch of purple, add details such as windows and the church clock. Ensure there is not too much contrast within each building.

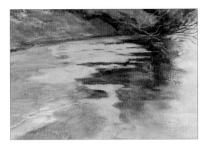

19. Finally, suggest sunlight on the duckweed using a mixture of lemon yellow and tiny spot of phthalo blue.

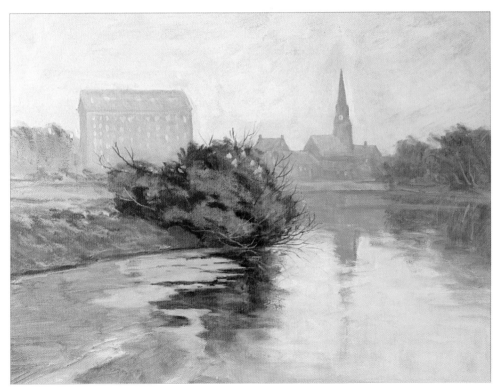

The finished painting.

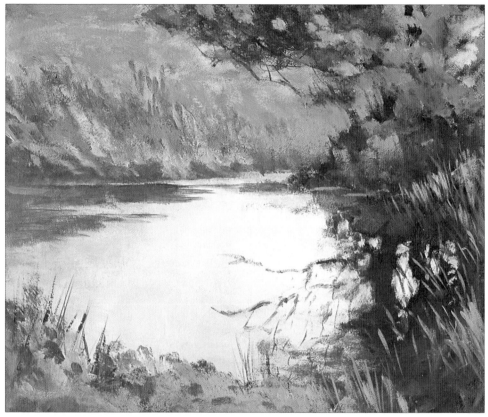

The Fishing Hole
30.5 x 25cm (12 x 9¾in)

This loose, simple study of still water is strengthened by selecting a high eye level. The only sky in the painting is within the reflection in the water, thus giving this picture an interesting 'upside-down' feeling. We can see that the water is still by the more defined reflection of the tree to the right. Avoid an exact mirror image as this can look a little false.

River Great Ouse at Hemingford Grey
30.5 x 23cm (12 x 9in)

I live near this river and love to include water in my paintings. Water, even if it is only in the form of puddles, allows you bring down the sky tones, giving more opportunity to create patterns by using light and reflection. Note the soft reflection under the buildings compared to the harder rippled reflection in the foreground. This adds perspective to the river.

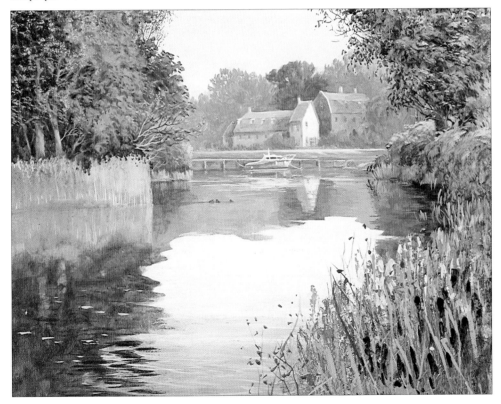

Ancient Tree

Trees can often make interesting subjects in their own right. This old ivy-covered tree is a case in point. The photograph is too cluttered and needs simplifying to create a successful composition. The farm buildings in the background are too distracting so I left them out. The ground was sloping and I emphasised this slope in the right-hand foreground. The fence and gate were simplified and I made the path through it clearer to provide a lead-in. There are one or two smaller trees in the photo which again, to lessen confusion, I simply left out.

You will need

Primed board, 46 x 36cm
 (18 x 14¼in)
Charcoal
Titanium white
Raw sienna
Naples yellow
Cadmium red
Burnt sienna
Burnt umber
Phthalo blue
French ultramarine
Chromium oxide green
Dioxazine purple
Natural sponge
Brushes:
 No. 6 and no. 10 flat
 No. 4 round
 Rigger
 Bungee brush

I normally carry a camera in my painting bag. Trees standing out on their own are worth recording and can often make paintings in their own right.

1. Draw a charcoal sketch of your picture on your primed board.

2. With the no. 10 flat brush, paint an underpainting using raw sienna for the light areas, dioxazine purple for the shadows and burnt sienna and purple for the mid-tones.

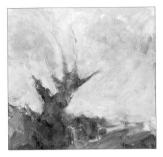

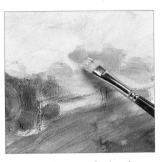

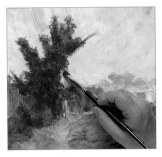

3. Mixing white with cadmium red and French ultramarine makes a slightly mauve grey. Vary the warmth of the sky by using different proportions of these colours as you paint.

4. Using the no. 6 flat brush, paint in distant trees with a mix of French ultramarine, Naples yellow and white.

5. Paint in the tree trunk using a mix of phthalo blue, burnt umber and a touch of Naples yellow. Before it dries, scumble around the edges with a dry brush to create the impression of ivy leaves.

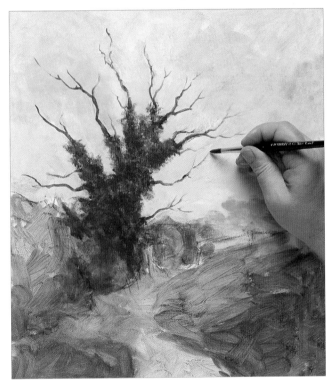

6. Water down the same mix and, with a no. 4 round brush, paint in the branches.

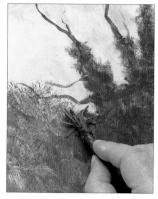

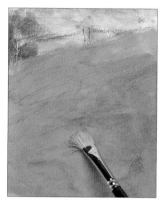

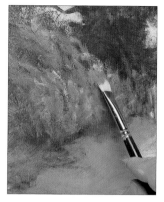

7. Use the bungee brush (or the sponge) to spread colour outwards. Press the brush into quite a wet area of paint and, working quickly, push it out towards the sky, twisting it as you go.

8. Using the no. 6 flat brush, roughly paint a mix of chromium oxide green and Naples yellow over the two banks in the foreground. Leave areas of the underpainting showing through.

9. Use a mix of burnt sienna and Naples yellow to create the impression of light in the hedgerow. Work from the bottom of the hedgerow upwards, mixing lighter shades as you go.

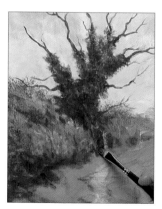

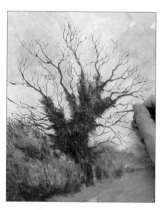

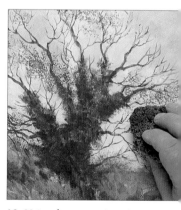

10. Use a mix of phthalo blue, burnt umber with a touch of Naples yellow to add shadow to the bottom of the hedgerow.

11. Make a watery mix of French ultramarine and burnt sienna. Using a rigger brush, add the finer branches and twigs to the tree.

12. Using the same mix as in step 11, lightly sponge in some remaining winter leaves.

44

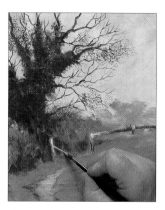

13. Use the no. 4 round brush to add fence posts. Mix burnt umber and French ultramarine for the dark parts of the fence and burnt umber and white for the lighter parts.

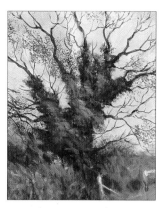

14. Mix a pale green using chromium oxide green, raw sienna and white and brush over the ivy with a no. 6 flat brush.

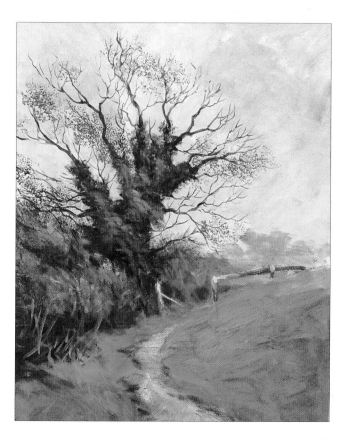

The finished painting.

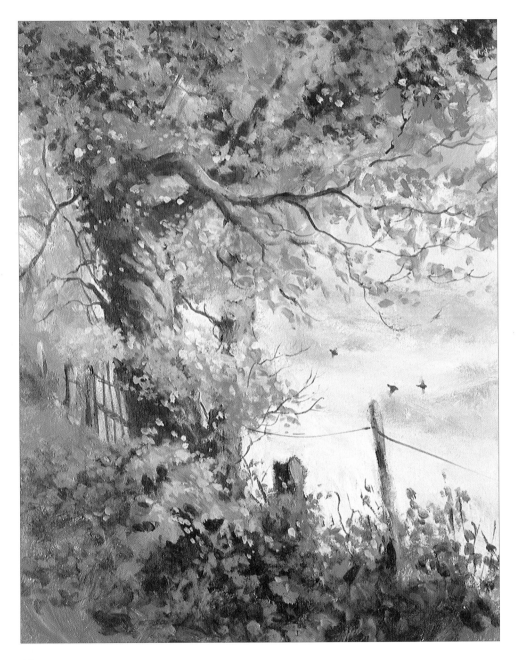

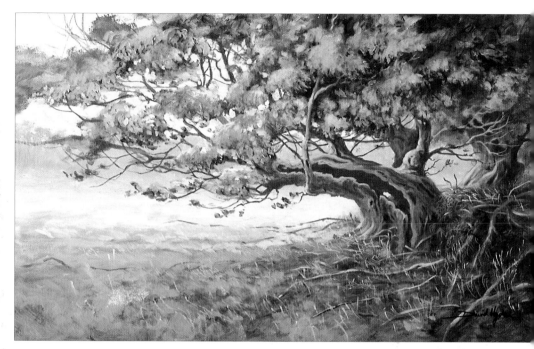

The Old Willow
43 x 25.5cm (17 x 10in)

*An old willow tree dominates this painting. To evoke its size, I have let most of the tree
disappear out of the top of the picture. Heavy shadow tones on the right have been
balanced with the sunlight in the meadow beyond on the left. A careful balance was
struck to depict the complexity of the foliage and branches without getting overly fussy.*

Opposite
Field Edge – Late Summer
25 x 30.5cm (9¼ x 12in)

The soft greens have been tempered with
ochre and sienna tones to give the feeling
of late Summer. In order to eliminate
confusion, detail has been removed from
the area on the right beyond the fence.
This whole area has been treated with
warm light tones to suggest soft Summer
sunshine. A rigger brush was used for the
twigs and the fence wire.

Index

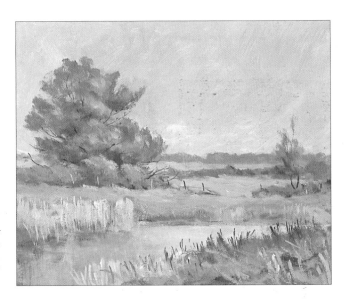

Fen Landscape near Cambridge
38 x 30.5cm (15 x 12in)

The tree is the focal point in this simple landscape study. This loosely painted picture attempts to capture the soft light of a warm summer's day. The sky tone and its reflection in the foreground water have been deepened and many of the tones in the landscape are lighter than the sky. The fence in the mid-distance has been simplified and the gap allows the eye through into the distance.